Praise for The

MW00772012

"*The Hookah Girl* is a blast of honest, wry an[...] of Marguerite Dabaie, who refuses to buy th[...] straight scoop not just on being a young Arab woman in the West, but how to be in a society challenged, as never before, to reconcile its democratic ethos with its (now officially sanctioned) legacy of intolerance. Her art takes us to important and forbidden places . . . and we are all enriched."
—Steve Brodner, illustrator, caricaturist, and political commentator

"Marguerite Dabaie is brilliant, and *Hookah Girl* is a revelation!"
—Randa Jarrar, President & Executive Director, Radius of Arab American Writers; author of *Him, Me, Muhammad Ali*

"Marguerite Dabaie navigates the swirling confluence of Palestinian heritage and American culture in these proud, poignant, and humorous stories of her upbringing. This is a lovely and humane book."
—Joe Sacco, author of *Palestine* and *Footnotes in Gaza*

"Reading *The Hookah Girl*, I felt like I was sitting in Dabaie's childhood home, surrounded by family, home cooking, laughter and stories of their homeland. This is a book that, like its author, refuses to squeeze itself into a box: full of heartbreak and humor, history and pride. I'm so glad that this collection of comics in all their intricate, loving detail are finally available to a wider readership. Its about time."
—Sarah Glidden, author of *How to Understand Israel in 60 Days* and *Rolling Blackouts*

"Through personal anecdotes, essays, and history lessons, the comix stories of *The Hookah Girl* confront the expectations thrust upon a young Palestinian American woman. By turns serious and joyful — but always honestly — Dabaie adds a vital perspective to the ongoing conversation."
—Josh Neufeld, author of *A.D.: New Orleans After the Deluge*

"Marguerite Dabaie's beautifully illustrated memoir *The Hookah Girl* is serious, heartbreaking, and seriously charming. A must-read."
—MariNaomi, author/illustrator of *Turning Japanese*;
creator of the Cartoonists of Color database

The Hookah Girl

And Other True Stories

Story and art by
Marguerite Dabaie

Rosarium Publishing
P.O. Box 544
Greenbelt, MD 20768-0544
www.rosariumpublishing.com

Printed in Canada

Table of Contents

The Struggle

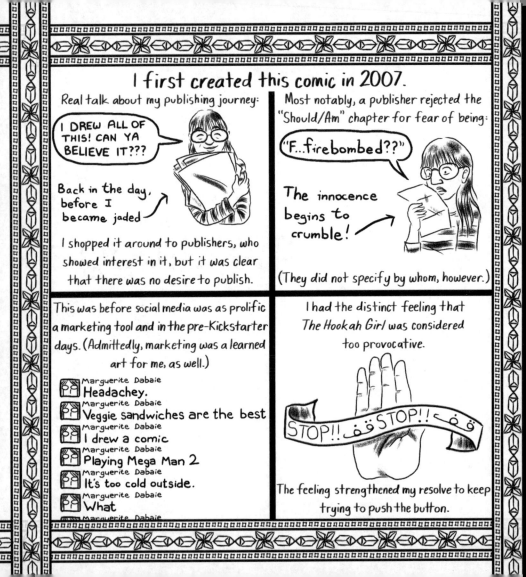

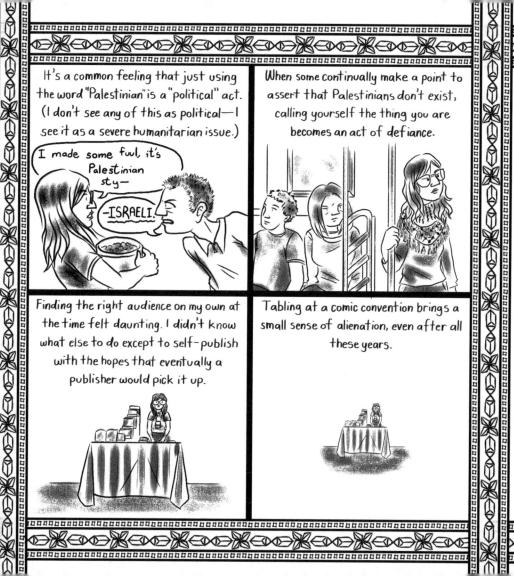

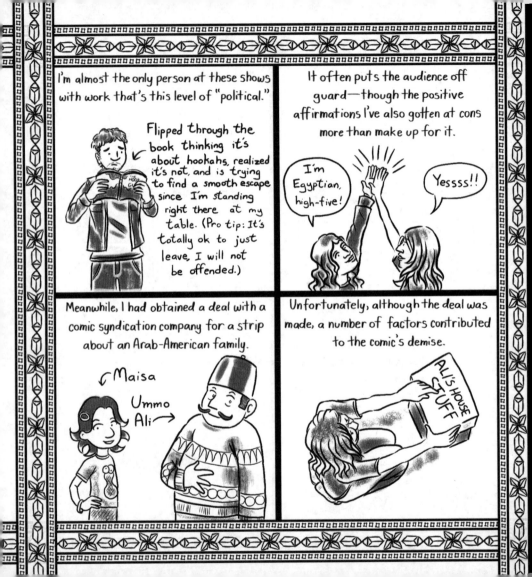

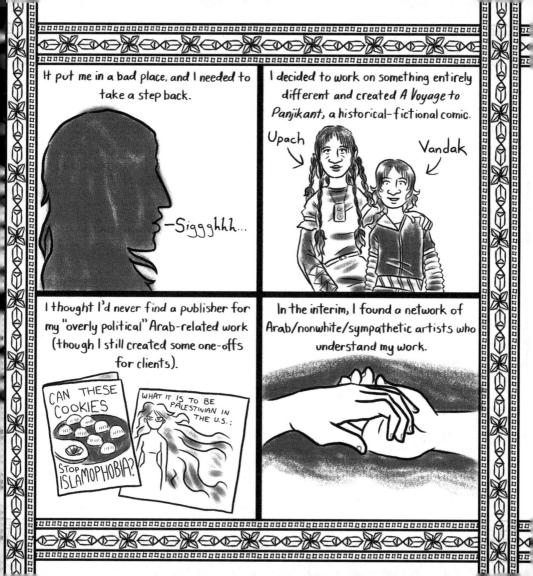

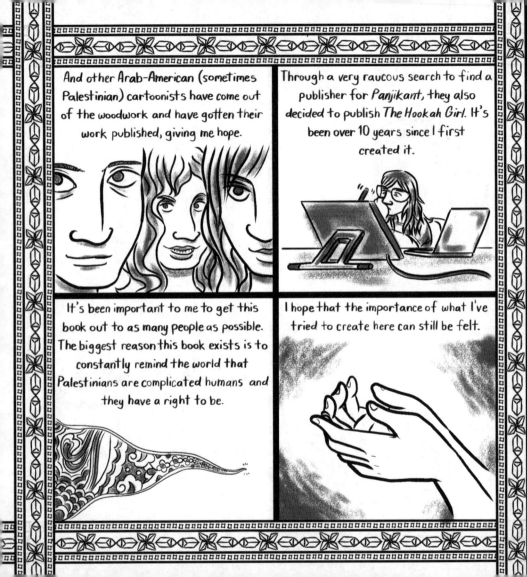

And other Arab-American (sometimes Palestinian) cartoonists have come out of the woodwork and have gotten their work published, giving me hope.

Through a very raucous search to find a publisher for *Panjikant*, they also decided to publish *The Hookah Girl*. It's been over 10 years since I first created it.

It's been important to me to get this book out to as many people as possible. The biggest reason this book exists is to constantly remind the world that Palestinians are complicated humans and they have a right to be.

I hope that the importance of what I've tried to create here can still be felt.

Should/Am

SHOULD / AM

Who Am I Today?

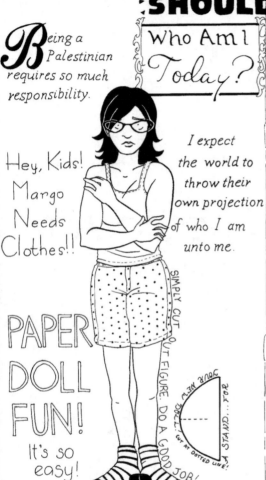

Being a Palestinian requires so much responsibility.

Hey, Kids! Margo Needs Clothes!!

I expect the world to throw their own projection of who I am unto me.

PAPER DOLL FUN!

It's so easy!

SIMPLY CUT OUT FIGURE. DO A GOOD JOB!

CUT AT DOTTED LINE! A STAND...FOR YOUR NEW DOLL

Muslim?

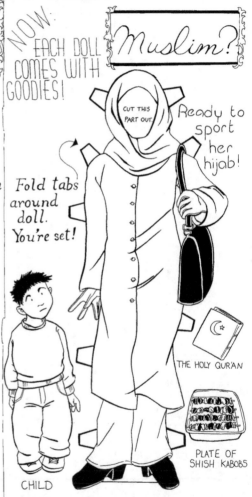

NOW: EACH DOLL COMES WITH GOODIES!

CUT THIS PART OUT.

Ready to sport her hijab!

Fold tabs around doll. You're set!

THE HOLY QUR'AN

PLATE OF SHISH KABOBS

CHILD

CUT GOODIES AROUND EDGE FOR EXTRA ACCESSORIES!!

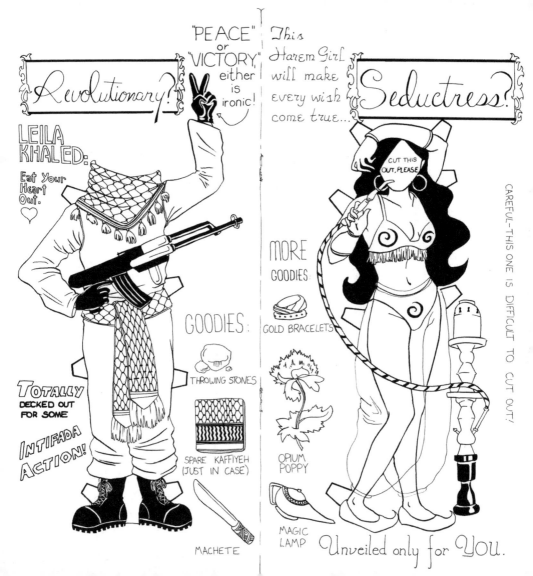

Martyr? OH, NO!

or Hungry Artist?

Not In Israel To Sight-see!

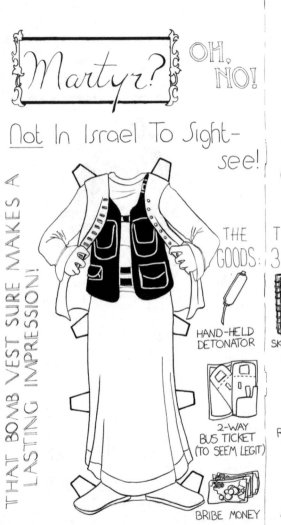

THAT BOMB VEST SURE MAKES A LASTING IMPRESSION!

THE GOODS:

HAND-HELD DETONATOR

2-WAY BUS TICKET (TO SEEM LEGIT)

BRIBE MONEY

THE 3 G's:

SKETCH PAD

CINNAMON RAISIN BAGEL

MANGO

I'm sorry to break it to you, but some Palestinians enjoy drawing and eating, as well.

Draws and eats all day!

The Hookah Girl

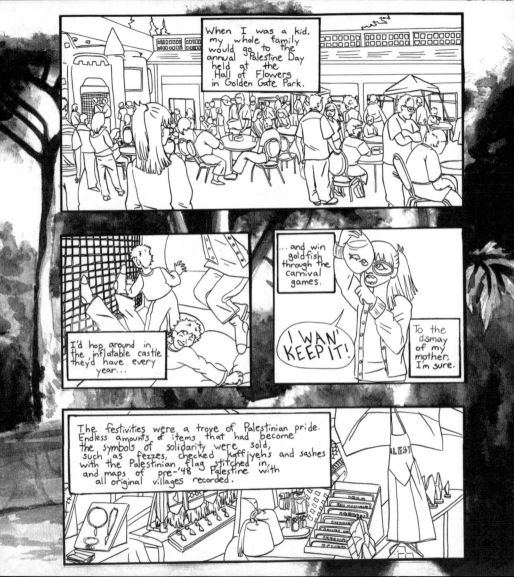

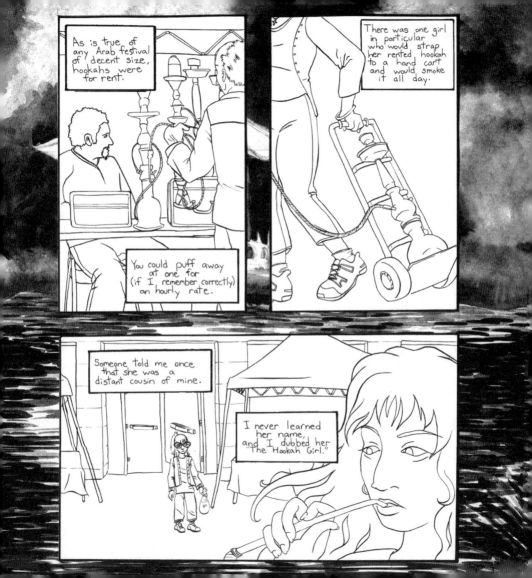

The True Arab Experience

The True Arab Experience

(In Five Easy Pages!)

This handy guide will help you with the Arab-American lifestyle!

Look for these signs:

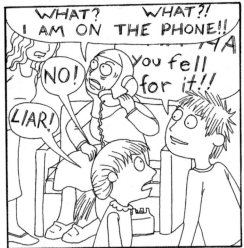

WHAT? WHAT?!
I AM ON THE PHONE!!

NO!

HA HA you fell for it!!

LIAR!

"Speaking 30 decibels louder than necessary."

So, I bleaded with that blumb bolice officer to let me sell that bile of bine blywood. He said no, so I tried bribing him with the bink bastel bastries. He just said leave the bile here and beel out.

I hate this bodunk town.

"P's turn into B's."

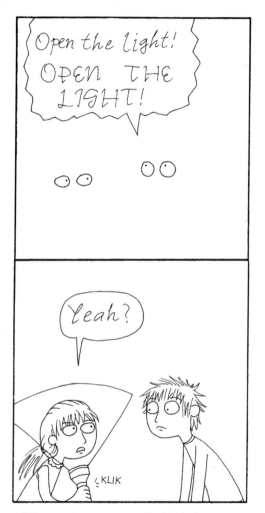

"Interesting uses of English
(A second language, after all!)."

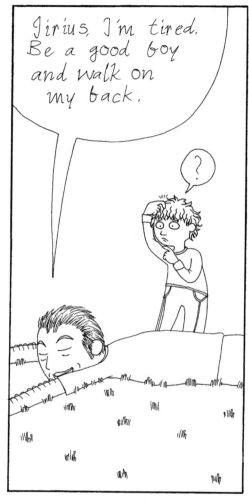

"Children are expected to earn
their keep by administering
cheap massages."

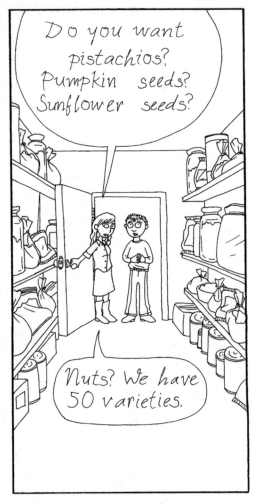

"So much bizzer (nuts and seeds) in the house at any given time."

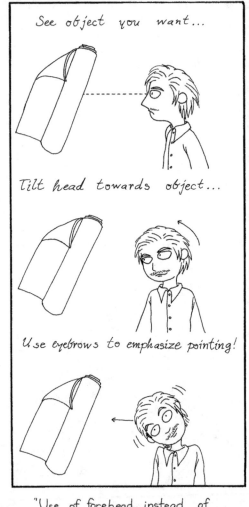

"Use of forehead, instead of fingers, to point. Extra credit if eyebrows are used effectively."

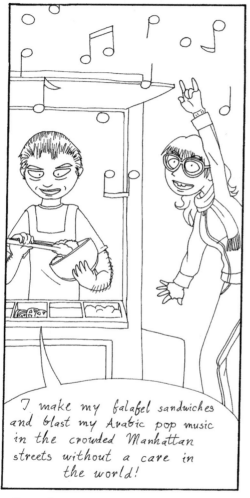

"At least one relative owns a grocery store, liquor store, restaurant, or falafel stand."

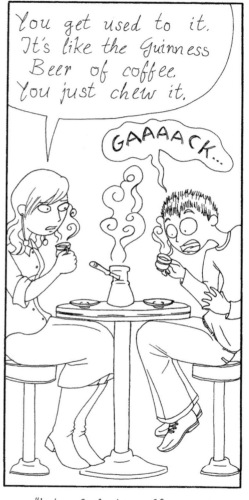

"Lots of Arabic coffee is consumed. Guests <u>must</u> be served Arabic coffee at all times!"

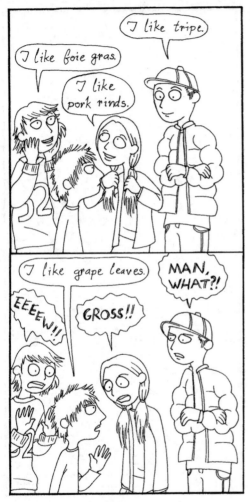

"Your favorite food might be grape leaves, but you're afraid to tell others you eat leaves."

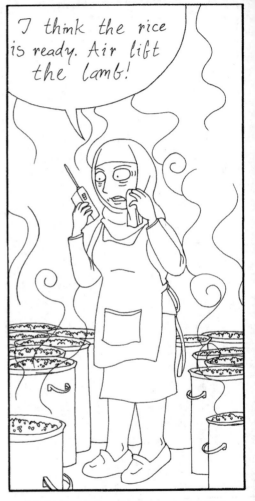

"And finally... Cooking meals that require the entire family's help and is enough food to feed a small army."

Rolling Leaves and the Grape Leaf Getaway Car

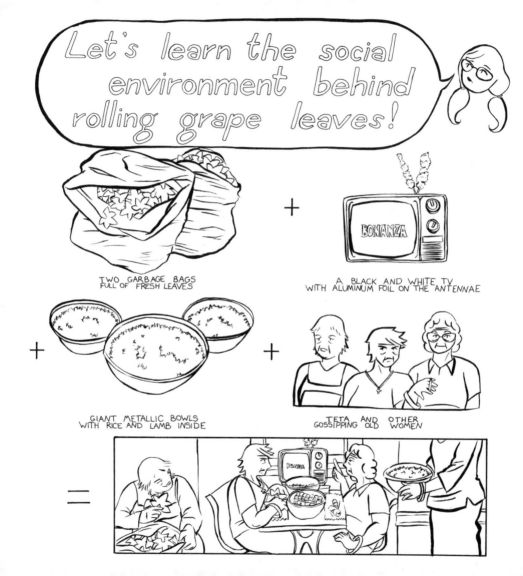

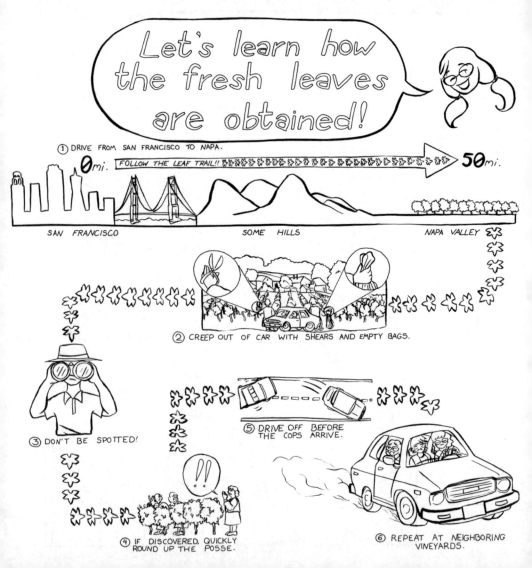

Domestic Goddess

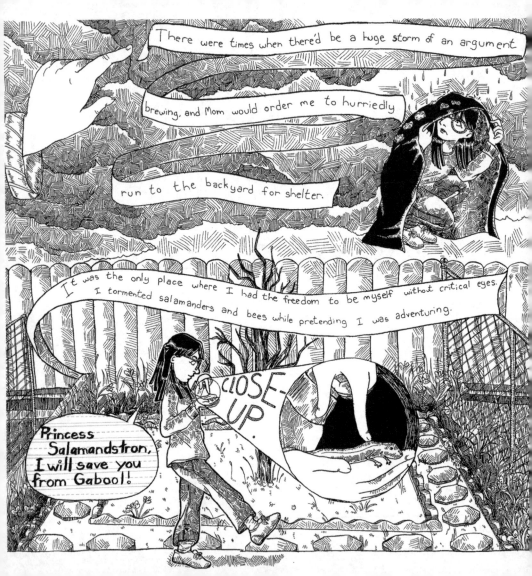

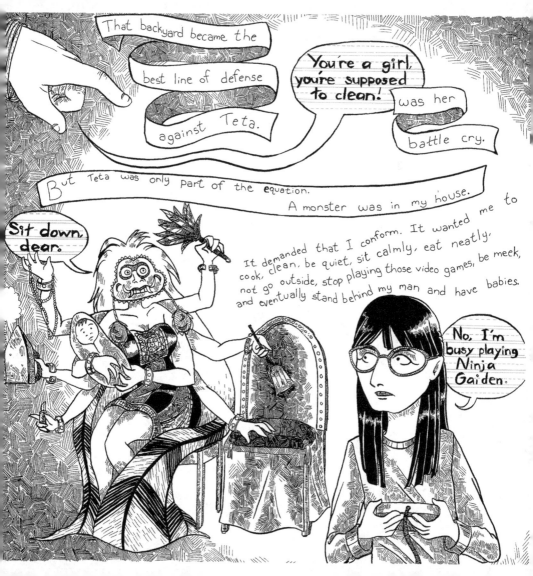

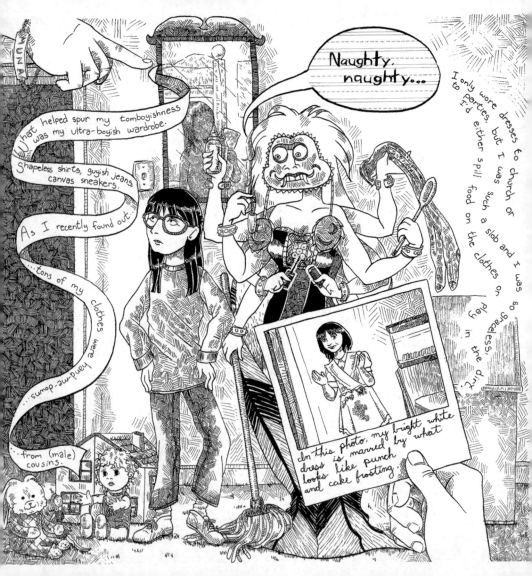

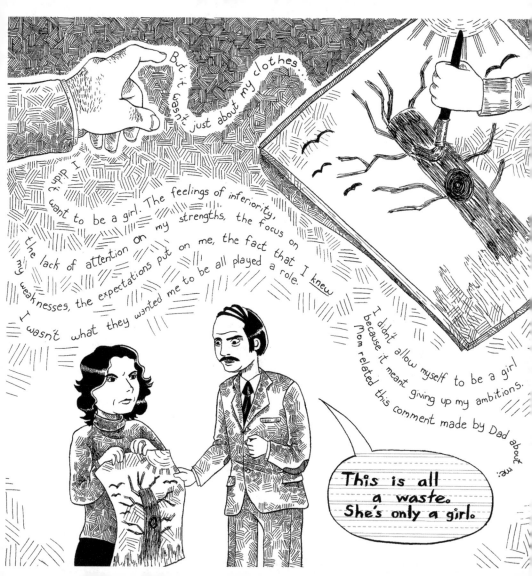

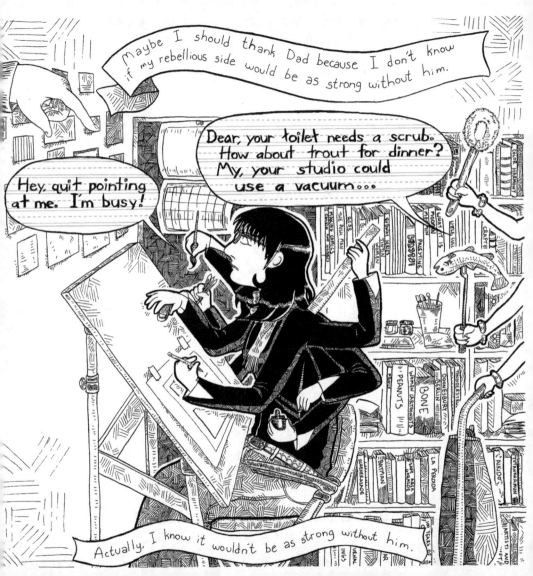

Arabs and Film
(Thank you to the late Jack Shaheen)

There's a certain movie that came out kind of recently. It was lauded as a feminist achievement because the protagonist was a strong woman who fought for the benefit of humanity and to (attempt to) end war.

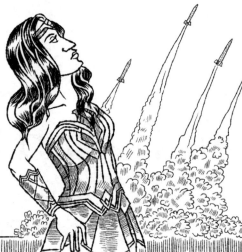

A lot of people went to see it, and I think most liked it. However, the film was banned in several Middle Eastern countries. Why? The lead actress was an Israeli who, at one point, was part of the Israeli Defense Forces and showed support for the 2014 war in the Gaza Strip that left over 2,000 Palestinians dead.

It didn't seem evident that Americans—unless they were tied to the Arab community—were aware of this or thought of boycotting for this reason.

I have to admit, I was struck by the irony. Here was this character who was so vehemently against war and convinced of the goodness of people that she was willing to fight to the death for them, played by an actress who saw no problem in the death of a large number of people specifically through war.

I can only imagine how the general public would have reacted if the actress were Arab, instead. But all I can do is imagine, since Arabs are almost ubiquitously portrayed as stereotypical, crooked, cartoonish villains.

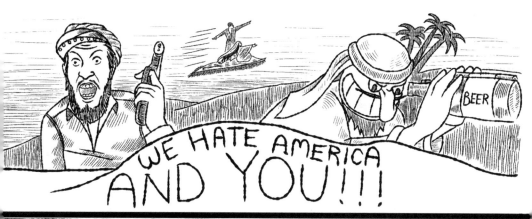

WE HATE AMERICA AND YOU!!!

BEER

I remember having a vague idea that they were meant to be Arabs, but the "Arabic" they scream is also a load of gibberish, so it confused me.

Do you remember "Back to the Future?" This movie particularly made an impression on me. There's some plot about how the Doc gets plutonium from "THE LIBYANS." They come barreling in with their van, screaming and brandishing guns, and murder the Doc.

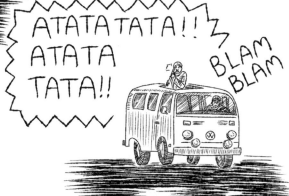

ATATATATA!! ATATA TATA!!

BLAM BLAM

And then there was Disney's "Aladdin." Who can forget the lyrics:

(It's barbaric... but hey... it's home?)

♪ "WHERE THEY ♪ CUT OFF YOUR EAR IF THEY DON'T LIKE YOUR FACE!

That line was later changed to "Where it's black and immense and the heat is intense," but I thought that was only marginally better, perpetuating more of that "mysterious Arabia" crap.

I was old enough at that point to know that "Aladdin" was definitely some riff of Arab culture, but then I was still confused because nothing in it looked like anything in my life, even counting that it's meant to take place in an obscure past.

Weird gauzy veil? Colorful harem pants?

Scimitars?

Bad guys = giant noses?

It was especially jarring since I watched a bunch of Arabic movies (all old, since Teta loved them) and the people in them were pretty, well, conventional.
From "Kady al-Belag"

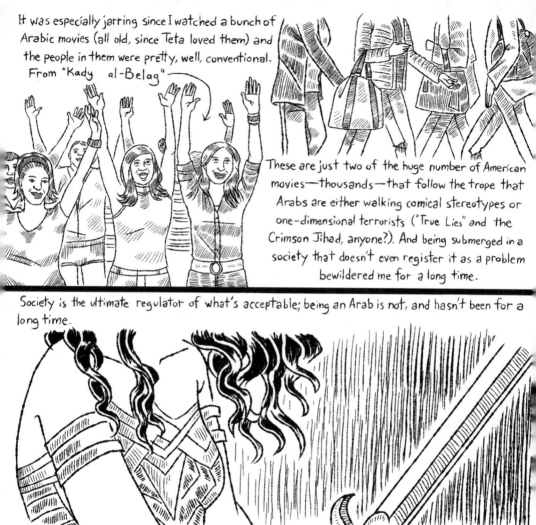

These are just two of the huge number of American movies—thousands—that follow the trope that Arabs are either walking comical stereotypes or one-dimensional terrorists ("True Lies" and the Crimson Jihad, anyone?). And being submerged in a society that doesn't even register it as a problem bewildered me for a long time.

Society is the ultimate regulator of what's acceptable; being an Arab is not, and hasn't been for a long time.

Until Arabs can play any character on the screen—including the hope-filled feminist hellbent on saving the world—the work of speaking up and questioning these decisions continues to be important.

The BestEST Joke!

The BestEST Joke! This one's a keeper!

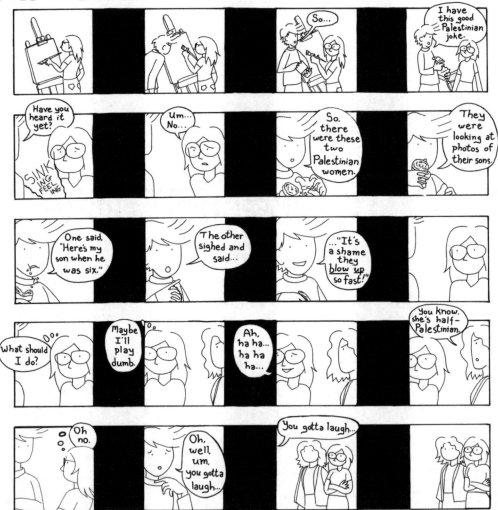

Music

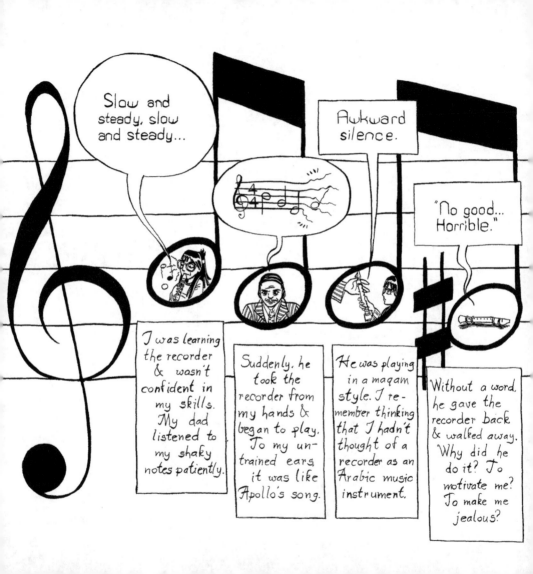

I am a man of the Dabaie Clan. I can do anything.

(However, my combover really was this bad.)

Do I play it like a guitar?

Played random notes, hoping the teacher wouldn't notice (she did).

I was so envious of his ability. I was not particularly encouraged to play music (or do anything artistic) since I was a girl & girls just didn't do those things.

I tried to teach myself the oud & the darbuka by practicing on his instruments when no one was looking. Dad wouldn't have any part in it.

My other attempts of learning an instrument through school failed. I felt it would have been looked down on if I practiced at home.

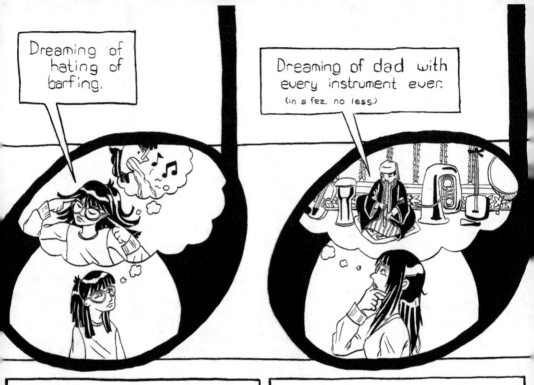

My "hatred" for music ran deep as an unattainable skill, & I refused to even listen to the stuff for several years. It's only been fairly recently that I've grown to love music again, though I still wish I was musically inclined.

I really want to think dad was a good player. With all the negative things I feel towards him, at least I could think "he's a good musician, it's not a total loss" & think it runs in the blood, or something like that. But the truth is that I'm not sure.

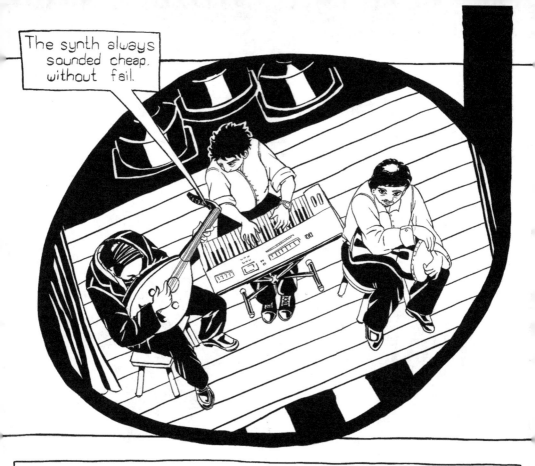

He was usually one of the musicians at the local parties. Just about every happy occasion was a large affair with sometimes hundreds of guests. An Arabic party band of the '80s only had 3 guys: One on a darbuka, one on an oud, & one on a synthesizer. I can't remember what dad played.

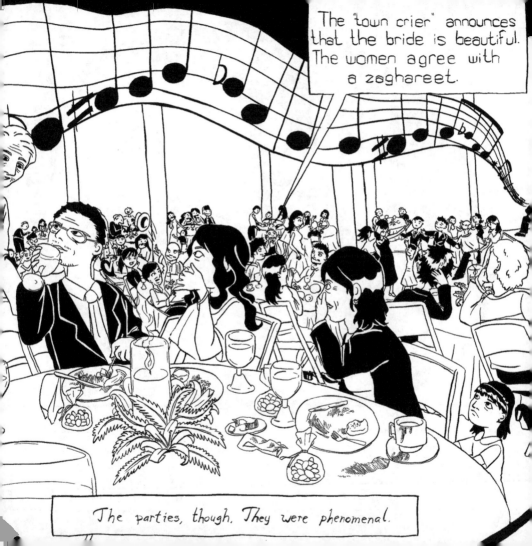

My Plight

There's even a minimal amount of spit! How is it possible?

MY PLIGHT

Sunflower seeds are a pain to eat.

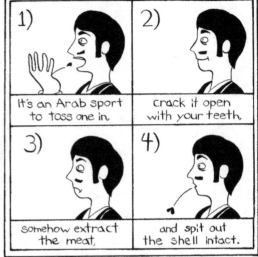

1) It's an Arab sport to toss one in

2) crack it open with your teeth,

3) somehow extract the meat,

4) and spit out the shell intact.

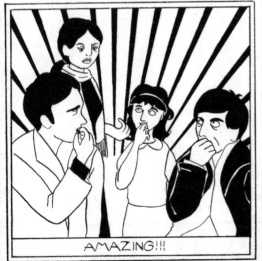

AMAZING!!!

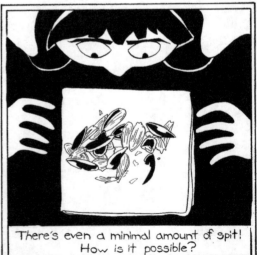

There's even a minimal amount of spit! How is it possible?

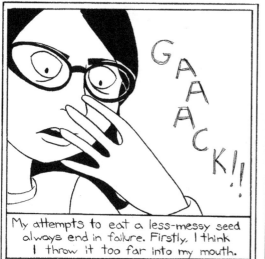

My attempts to eat a less-messy seed always end in failure. Firstly, I think I throw it too far into my mouth.

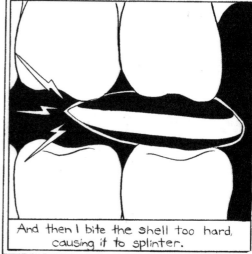

And then I bite the shell too hard, causing it to splinter.

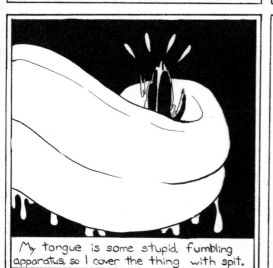

My tongue is some stupid, fumbling apparatus, so I cover the thing with spit.

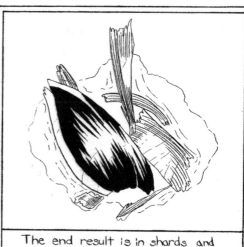

The end result is in shards and practically swimming in the Pacific. Gross.

1988: I'm looking at a RAMALLAH NEWSLETTER.

Little did I realize what I was getting myself into.

Naji al-Ali

OBOY! A
COMIC!
I like comics.

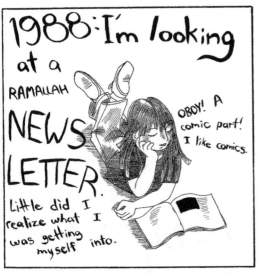

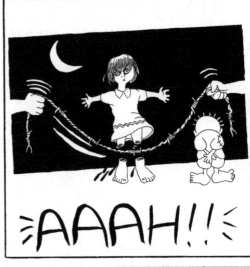

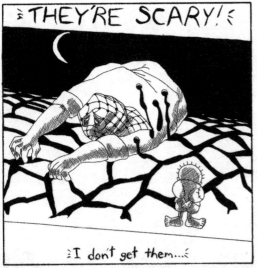

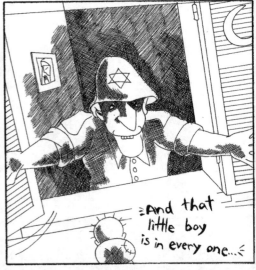

present: I still find the comics SCARY, but I think I understand their importance now.

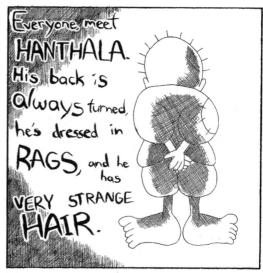

Everyone, meet HANTHALA. His back is always turned, he's dressed in RAGS, and he has VERY STRANGE HAIR.

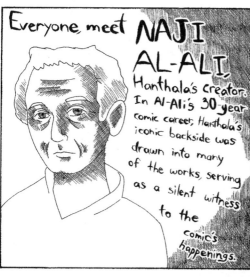

Everyone, meet NAJI AL-ALI, Hanthala's creator. In Al-Ali's 30-year comic career, Hanthala's iconic backside was drawn into many of the works, serving as a silent witness to the comic's happenings.

AND WHAT HAPPENINGS THEY WERE...

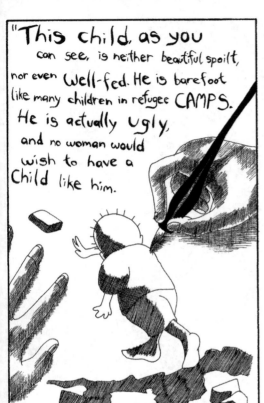

"This child, as you can see, is neither beautiful spoilt, nor even well-fed. He is barefoot like many children in refugee CAMPS. He is actually ugly, and no woman would wish to have a child like him.

However, those who came to know Hanthala, as I discovered, later adopted him because he is affectionate, honest, outspoken and a BUM...His hands behind his back are a SYMBOL of rejection of all the present NEGATIVE TIDES in our region."

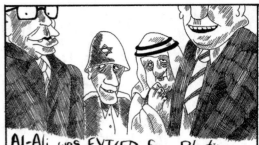

Al-Ali was EXILED from Palestine in '48 and lived in a Lebanese refugee camp. The comics he drew made him many enemies, and by the end of his life he was FORBIDDEN to visit many Middle Eastern countries.

Seeing these comics, it really is no WONDER. Since he had no political or religious affiliation, he antagonized everyone. ARABS JEWS, influential FIGURES, and international POLITICS were not safe.

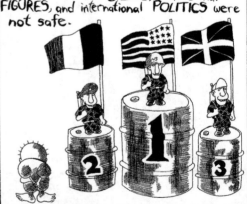

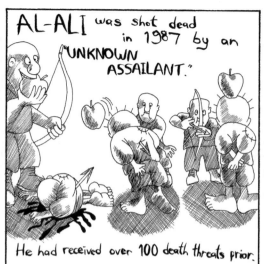

AL-ALI was shot dead in 1987 by an "UNKNOWN ASSAILANT."

He had received over 100 death threats prior.

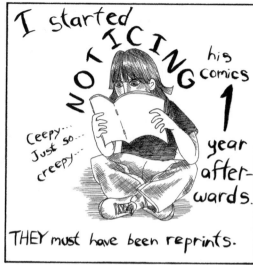

I started NOTICING his comics 1 year afterwards.

Ceepy... Just so... creepy...

THEY must have been reprints.

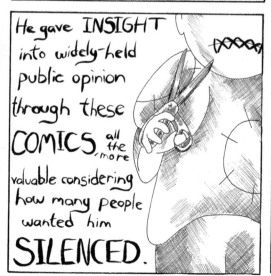

He gave INSIGHT into widely-held public opinion through these COMICS, all the more valuable considering how many people wanted him SILENCED.

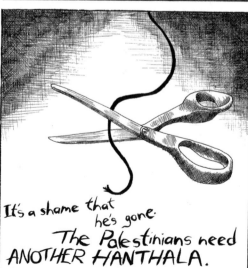

It's a shame that he's gone. The Palestinians need ANOTHER HANTHALA.

Textiles

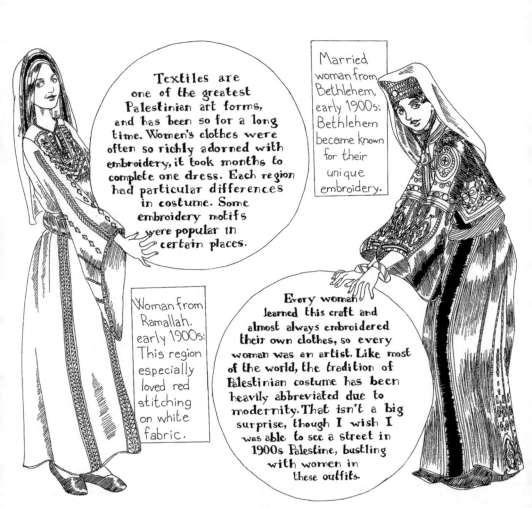

Textiles are one of the greatest Palestinian art forms, and has been so for a long time. Women's clothes were often so richly adorned with embroidery, it took months to complete one dress. Each region had particular differences in costume. Some embroidery motifs were popular in certain places.

Married woman from Bethlehem, early 1900s: Bethlehem became known for their unique embroidery.

Woman from Ramallah, early 1900s: This region especially loved red stitching on white fabric.

Every woman learned this craft and almost always embroidered their own clothes, so every woman was an artist. Like most of the world, the tradition of Palestinian costume has been heavily abbreviated due to modernity. That isn't a big surprise, though I wish I was able to see a street in 1900s Palestine, bustling with women in these outfits.

Some Embroidery Motifs...

Eye of the Camel

Star of Feathers

Woman from Jerusalem, early 1900s: This region was known for their eclectic fashions.

Kohl Pot

Foreign Moon

Cypress Tree

The Pasha's Tent

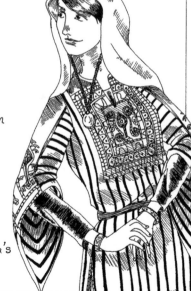

The information in this story was taken from Jehan Rajab's _Palestinian Costume_, Kegan Paul Intl., 1989.

The Stealth Arab

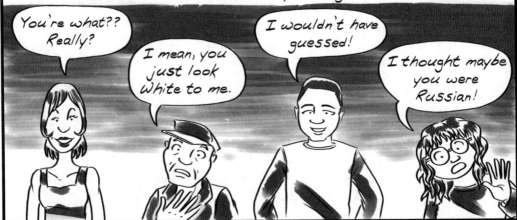

I'm what I call a "stealth Arab." That means these types of reactions are common when my heritage is discovered:

You're what?? Really?

I mean, you just look White to me.

I wouldn't have guessed!

I thought maybe you were Russian!

I'm half Arab and half White—a nus-nus. While I'm extremely pasty, I actually share a lot of similar features (including skin tone) with my Palestinian father.

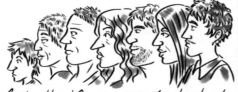

Actually, if one were to look at my family, we're a pretty diverse bunch, ranging from darker to lighter skin.

I get the feeling that when people think of Arabs in general, the look they think of is more along the lines of darker skin, a big nose, curly, black hair, and large, dark eyes. (Some definitely do look this way.)

But there are two things at play here: 1) The Middle East is an extremely large swath of land and encompasses over a dozen countries.

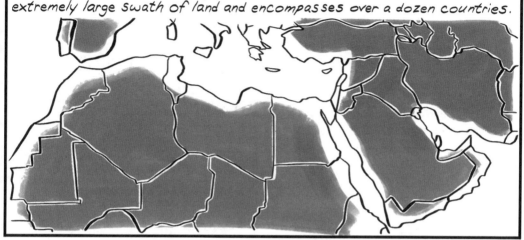

2) It's situated where the Silk Roads passed, meaning a large number of different kinds of people traveled to and from the Middle East for hundreds of years.

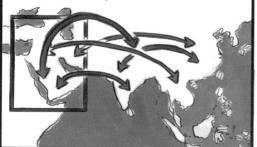

I took a DNA test recently and something unexpected came up:

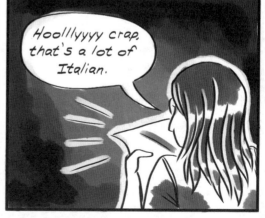

Hoolllyyyy crap, that's a lot of Italian.

The percentage is high enough that I suspect Teta was full-blooded Italian.

But she was Arab. She was fluent in Arabic and only spoke halting English because she had to, she cooked the best Palestinian food I had ever tasted, and she became a refugee in 1967 just like so many other Palestinians before and since.

Teta making sfiha

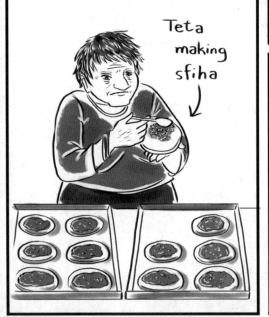

Here's the thing: While the Italian bloodline was new information, it wasn't necessarily surprising to me.

As I mentioned, people have been traveling to and from the Middle East for a long time. This is especially the case in Palestine, important to three major religions.

JERUSALEM: A big deal to Christianity, Islam, and Judaism.

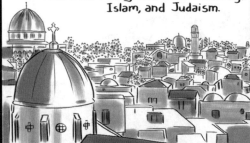

Palestine was always very ethnically diverse. Borders were porous, and, as I like to say, the entire concept of regional borders is very Western.

Throughout its history it was under the rule of the Romans, the Islamic Empire, the Ottomans, and the British.

But okay, let's make this more concrete: Teta's parents would have been around during the Ottoman Empire. What was that like from an immigration perspective?

"The activities of European merchants in the coastal towns of Palestine were unimpeded by the Ottomans. . . . By the mid-nineteenth century, many European powers had consulates in the country, and during the second half of the century Christian missions . . . proliferated along with their schools, hospitals, printing presses, and hostels. Of all the Arab provinces in the Ottoman Empire . . . Palestine was the most exposed and accessible to Christian and European influences."[1]

There's no question some of them stayed.

1. Institute for Palestine Studies, Special Focus: Ottoman Palestine, http://www.palestine-studies.org/resources/special-focus/ottoman-palestine

It's not unheard of for an outside ethnic group to move into Palestine and assimilate after a couple of generations. In the late 1800s, a number of Muslim families from Bosnia immigrated to Palestine, eventually socially blending in with the population. Now, only the family name of Bushnaq is any indication of their origins.[2]

2. Institute for Palestine Studies, Special Document File: the Herzegovinian Muslim Colony in Caesarea, Palestine, http://www.palestine-studies.org/sites/default/files/jps-articles/JPSr77_06_Li_Seferovich.pdf

And, of course, during the Nakba—the mass expulsion of Palestinians in 1948—they were treated exactly the same as the locals.

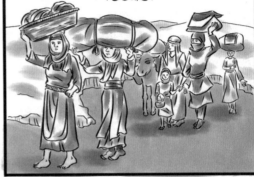

The multicultural element of Palestine isn't often talked about. I think because Zionism often likes to use it as an argument that "Palestinians aren't really Palestinians and don't belong there." "Questions of race and ethnicity among Palestinians have remained underexplored and potentially sensitive. Zionist writing has long emphasized the migration of diverse non-Jewish populations to Palestine prior to the Nakba . . . to question the existence of a Palestinian nation or to downplay the impact of Zionist colonization on Palestine."[3]

3. See footnote 2.

Since I'm a nus-nus, I have a longing for people who look like me or experience life like I do, because, with this genetic and cultural makeup, it's a bit of a unique experience, to say the least.

I tried searching for Sicilian and Italian faces online to see if they looked anything like me. Honestly? I didn't see it.

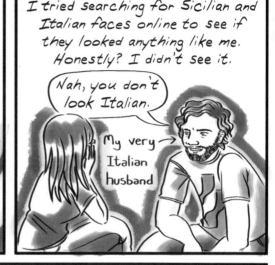

Nah, you don't look Italian.

My very → Italian husband

Then I tried looking up Palestinian faces. They covered a range of facial features and skin tones. And I found some that looked like me. It drove home that our shared history is one of diversity. We also share the same fate. And even though history has been cruel, I'm proud of it.

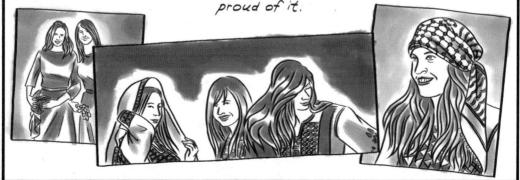

The Birthday Party

THE BIRTHDAY PARTY

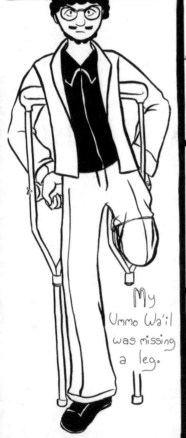

My Ummo Wa'il was missing a leg.

He used a rubber band to hold the excess pant fabric to his stump.

He lost the leg because he needed to fix his car and had the leg dangling out towards oncoming traffic.

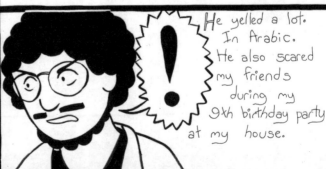

He yelled a lot. In Arabic. He also scared my friends during my 9th birthday party at my house.

What Leila Khaled Said

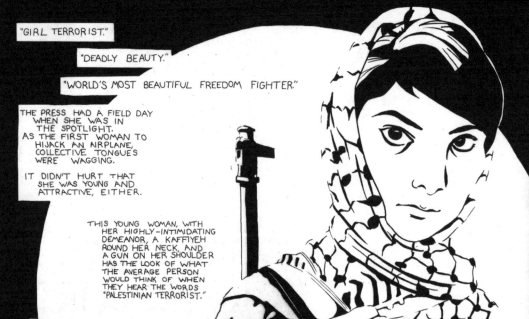

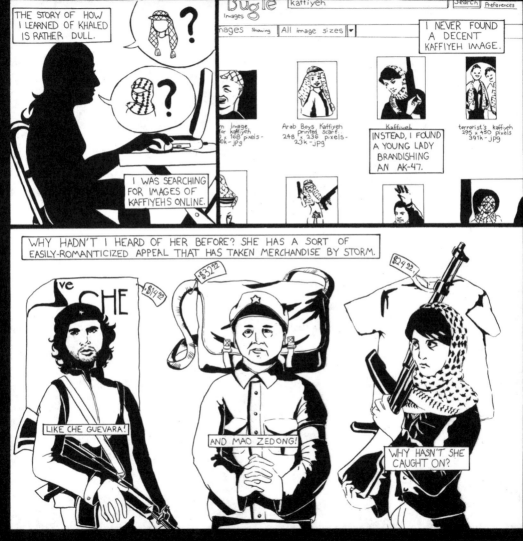

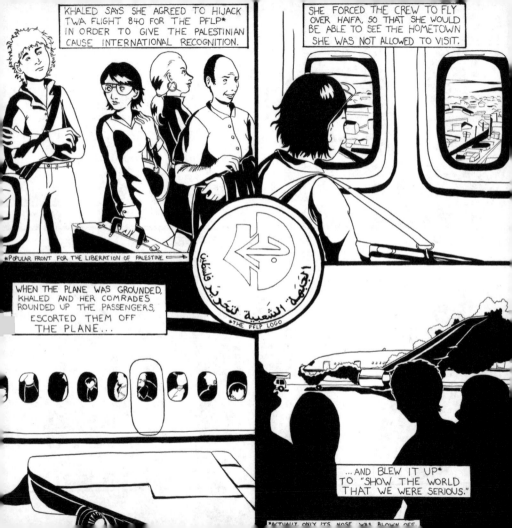

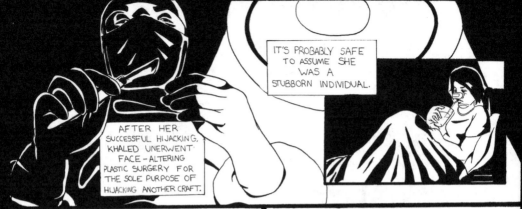

IT'S PROBABLY SAFE TO ASSUME SHE WAS A STUBBORN INDIVIDUAL.

AFTER HER SUCCESSFUL HIJACKING, KHALED UNERWENT FACE-ALTERING PLASTIC SURGERY FOR THE SOLE PURPOSE OF HIJACKING ANOTHER CRAFT.

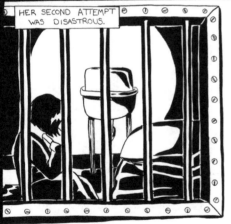

HER SECOND ATTEMPT WAS DISASTROUS.

HER COLLEAGUE WAS KILLED, AND SHE WAS IMPRISONED IN LONDON. HOWEVER, A MAN NOT PART OF THE PFLP HIJACKED ANOTHER PLANE, DEMANDING HER RELEASE. THE GOVERNMENT OBLIGED.

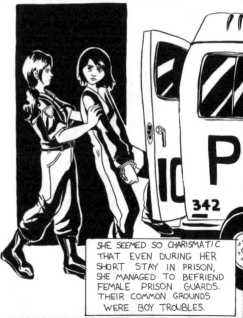

SHE SEEMED SO CHARISMATIC THAT EVEN DURING HER SHORT STAY IN PRISON, SHE MANAGED TO BEFRIEND FEMALE PRISON GUARDS. THEIR COMMON GROUNDS WERE BOY TROUBLES.

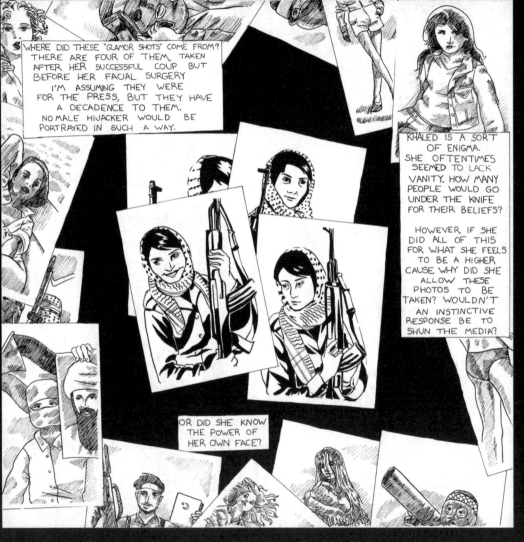

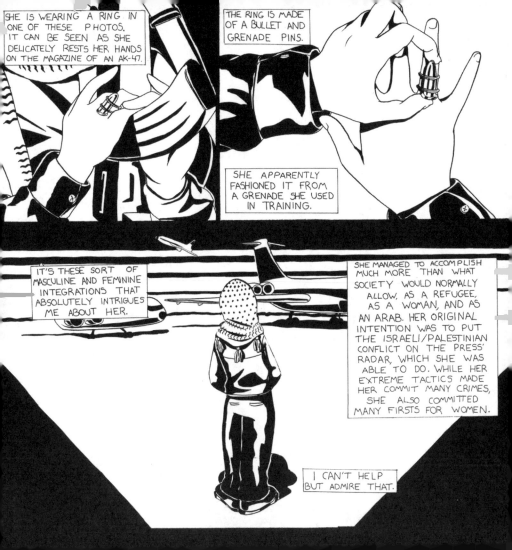

NOW

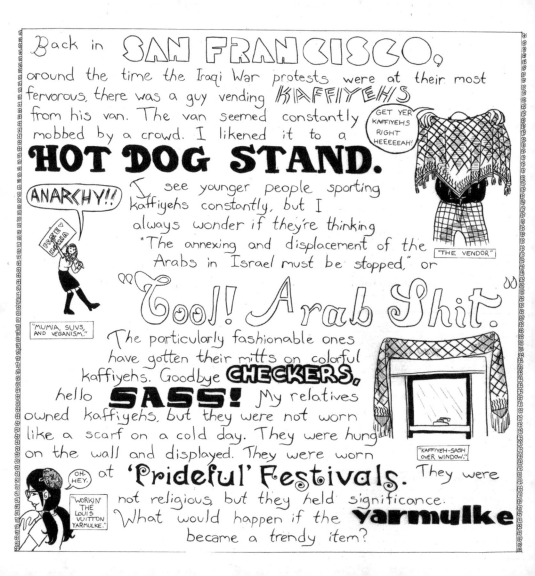

Folk Medicine

PILLS FOR BLOOD PRESSURE, KIDNEYS, HEART PROBLEMS, DIABETES, ASTHMA, ARTHRITIS...

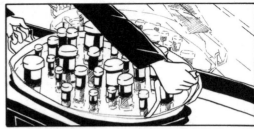

MY GRANDPARENTS HAD QUITE THE ARSENAL, AND THEY WERE ALL KEPT ON A SILVER TRAY IN THE LIVING ROOM.

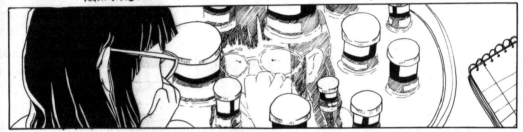

I LIKED TO LOOK AT MYSELF IN THE REFLECTION OF THE TRAY, BETWEEN THE SCORES OF ORANGE BOTTLES.

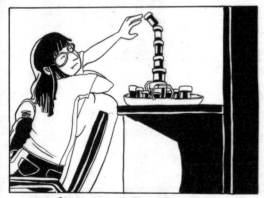

HOW IRONIC IT WAS TO HAVE SUCH A BEAUTIFUL TRAY BLEMISHED BY THESE MACABRE THINGS.

AWW, MAN!

THIS WESTERNIZED PILL-POPPING MUST HAVE BEEN A CULTURE SHOCK WHEN THEY FIRST MOVED HERE.

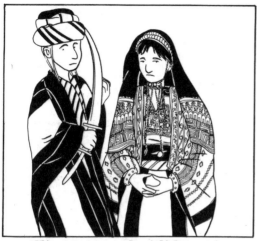

TETA AND SIDO WERE MARRIED YOUNG, AS WAS THE CUSTOM IN EARLY 20TH CENTURY PALESTINE.

IN FACT, TETA WAS SO YOUNG, SHE HAD NOT GONE THROUGH PUBERTY YET AND WAS THEREFORE UNABLE TO PROCREATE.

HER PRESCRIPTION WAS TO VISIT THE HOMES OF EVERY WOMAN IN LABOR IN RAMALLAH...

...AND WITNESS THE BIRTHS. THE BIRTHING SMELL WAS SAID TO CURE INFERTILITY.

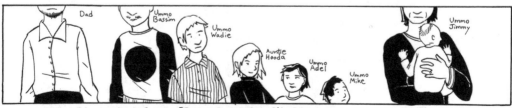

SHE WAS SOON ABLE TO PRODUCE SEVEN CHILDREN, SIX OF THEM SONS. MAYBE THE SMELLS WORKED, AFTER ALL.

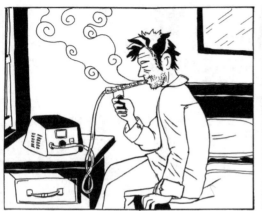

SIDO DRANK AND SMOKED A LOT
WHEN HE WAS YOUNGER,
SO HIS LIVER WAS SHOT AND HE HAD EMPHYSEMA.

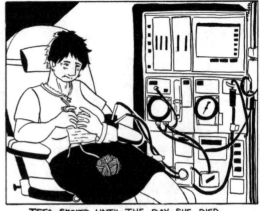

TETA SMOKED UNTIL THE DAY SHE DIED
AND ALSO HAD SUCH HIGH BLOOD PRESSURE FOR SO LONG,
HER KIDNEYS WERE SHOT.

THEY WERE BOTH AWFULLY SICK, AS LONG AS I CAN REMEMBER.
THEY WERE OBVIOUSLY FAR FROM BEING THE PERFECT MODELS OF HEALTHY HABITS,
BUT IT LEADS ME TO WONDER IF THEY ULTIMATELY BELIEVED
IN ALL THAT WESTERN MEDICINE.

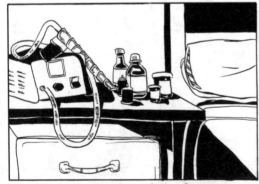

THEY WERE DILIGENT ABOUT RECEIVING
THEIR MEDICATION WHEN THEY
WERE ALIVE.

BUT ALL THAT MEDICINE DIDN'T HELP
IN THE END.

AND OLD HABITS DIE HARD...

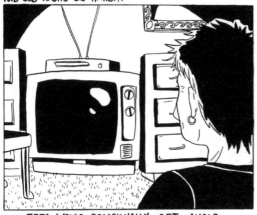

TETA WOULD OCCASIONALLY GET AHOLD OF "MIRACLES ON FOOTAGE" THAT INCLUDED (BUT NOT LIMITED TO):

THE GIRL AFFLICTED WITH THE STIGMATA (CUE SOULFUL, CROONING WOMAN IN THE AUDIO TRACK).

THE GIRL WITH HEALING PROPERTIES WHO WOULD LEAK HOLY OIL FROM HER HANDS.

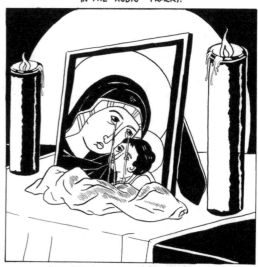

AND THE ICON OF THE VIRGIN THAT CRIED HOLY OIL.

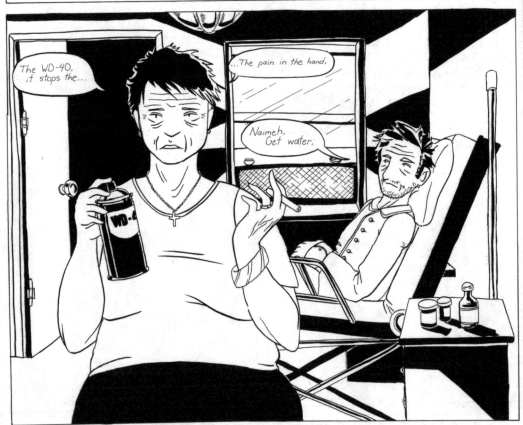

DO YOU?

Glossary

You might have noticed a few non-English words and phrases while reading. Here are some definitions:

<u>BIZZER:</u> Snacks to nosh on. Think of the bowl of candy in your grandma's living room except fill the bowl with nuts and seeds.

<u>DARBUKA:</u> A goblet drum that goes by many names throughout the Mediterranean, Middle East, Africa, and Eastern Europe. It makes a great sound!

<u>FEZ:</u> Also known as a tarboosh. The iconographic conical red hat with a tassel on top. In Palestine, especially in the 19th and early 20th centuries, urban sophisticates tended to wear them.

<u>INTIFADA:</u> Literally translates to "shaking off" in Arabic. It's used as slang to describe the recent Palestinian uprisings against Israel.

<u>KAFFIYEH:</u> A checked cloth usually worn by Arab men. Traditionally, it is draped atop the head and held in place with a ring that encircles the head. Its original colors are black, green, or red stitching on white cloth. Recent developments have dictated that particular colors represent different political factions and that black-and-white kaffiyehs especially represent the Palestinians.

MAQAM: A melodic system used in traditional Arabic music. I'm unable to get any more detailed than that, but once you hear it, you know it!

OUD: A Mediterranean and Middle Eastern stringed instrument. Unlike the flat back of a guitar, it features a half-a-watermelon-like back (and it often has a striped back, like a watermelon).

SFIHA: An open meat pie. The recipe that I'm used to uses ground lamb, lots of nutmeg, and pine nuts.

SIDO: Arabic for, literally "my grandfather."

TETA: Arabic for "grandmother."

ZAGHAREET: An ululation often made during celebrations by the women present. It sounds like a loud trilling and the women usually cover their mouths while doing it.

A sketch drawn very early in the project on the topic of Palestinian-style sleeves.

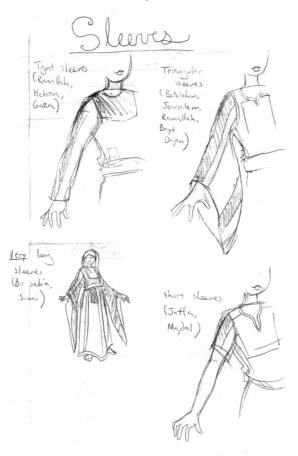

Sleeves

Tight sleeves (Ramallah, Hebron, Gaza)

Triangular sleeves (Bethlehem, Jerusalem, Ramallah, Bayt Dajan)

Very long sleeves (Bir sebá, Sinai)

short sleeves (Jaffa, Majdal)